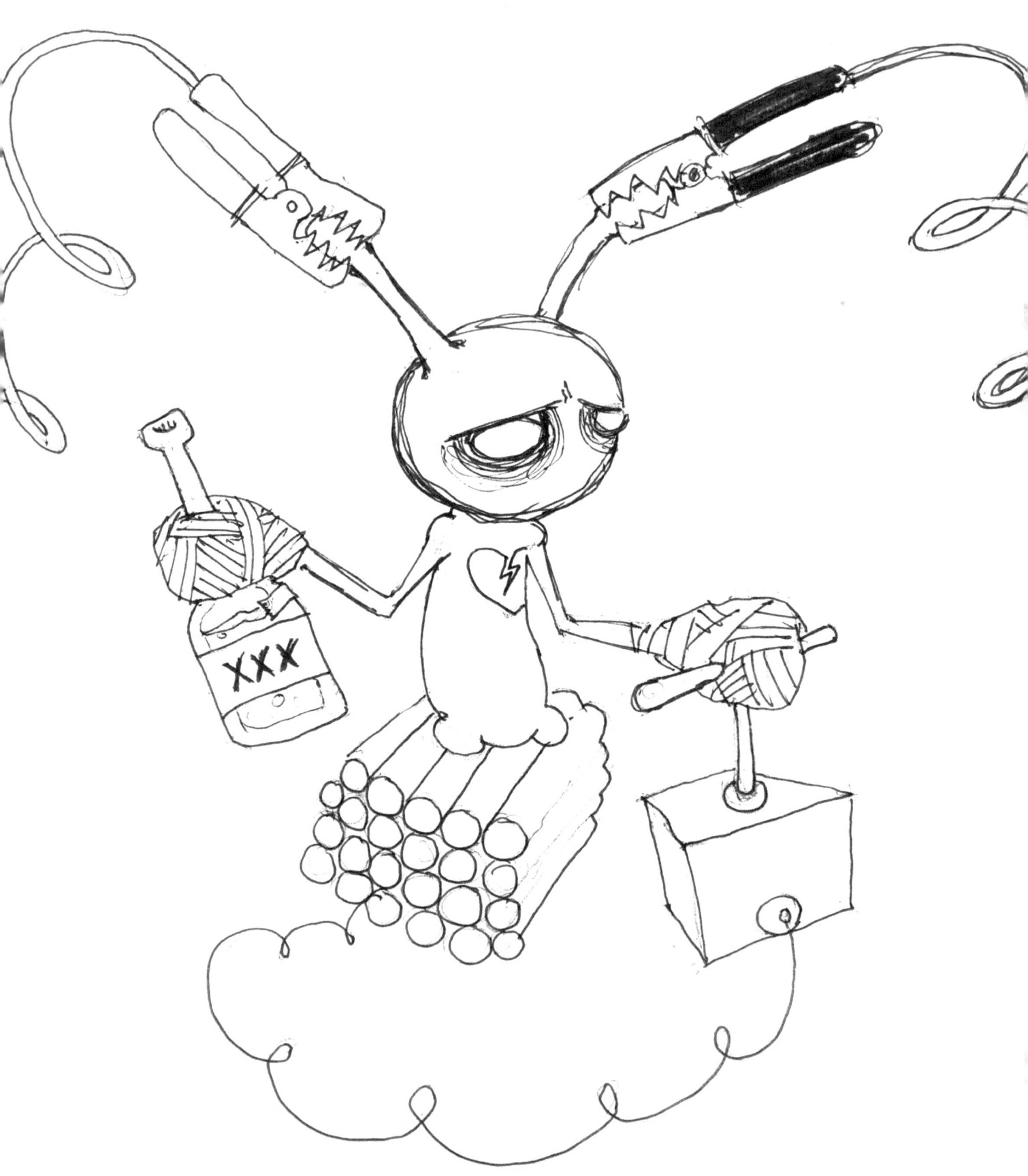

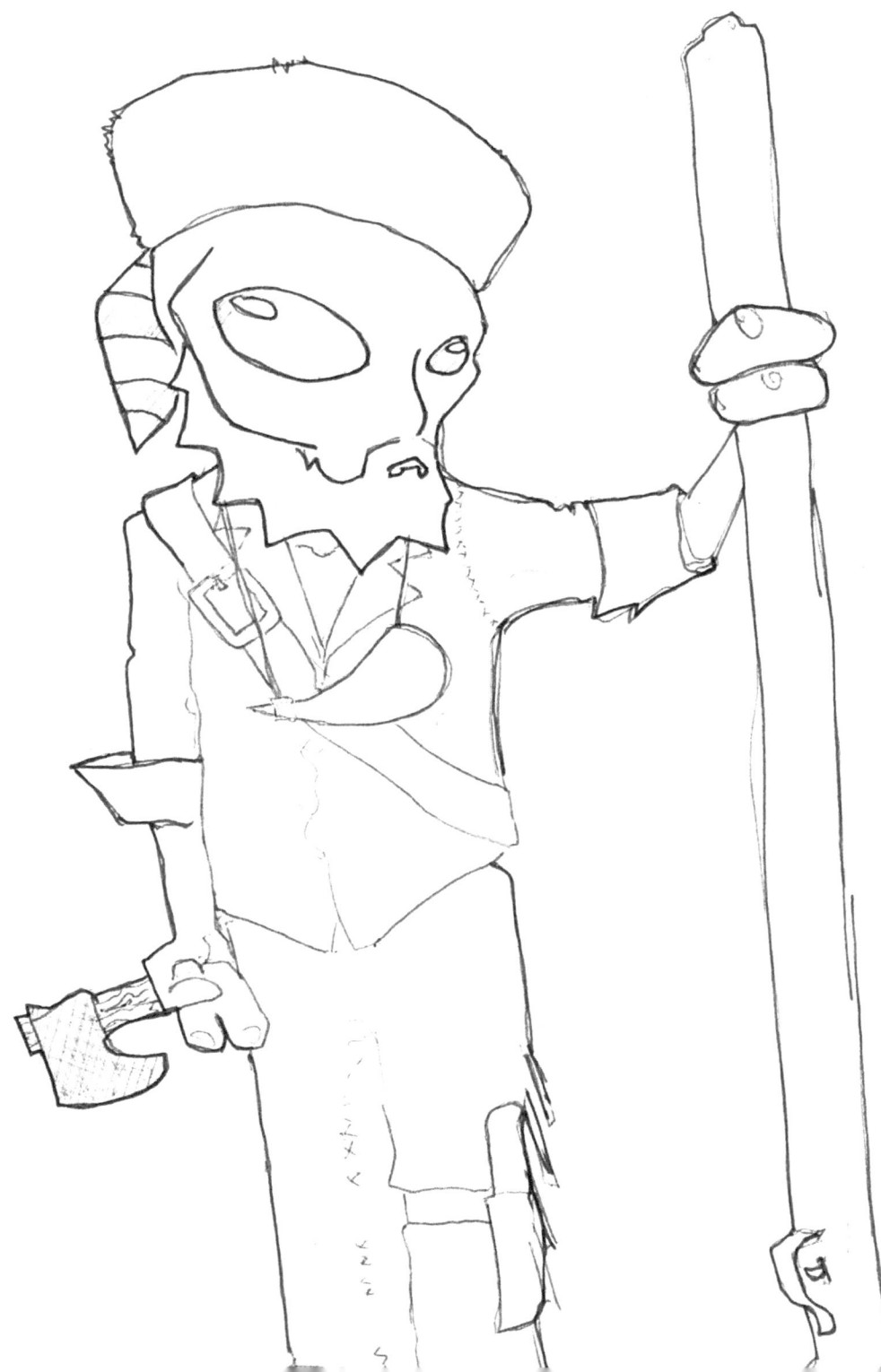

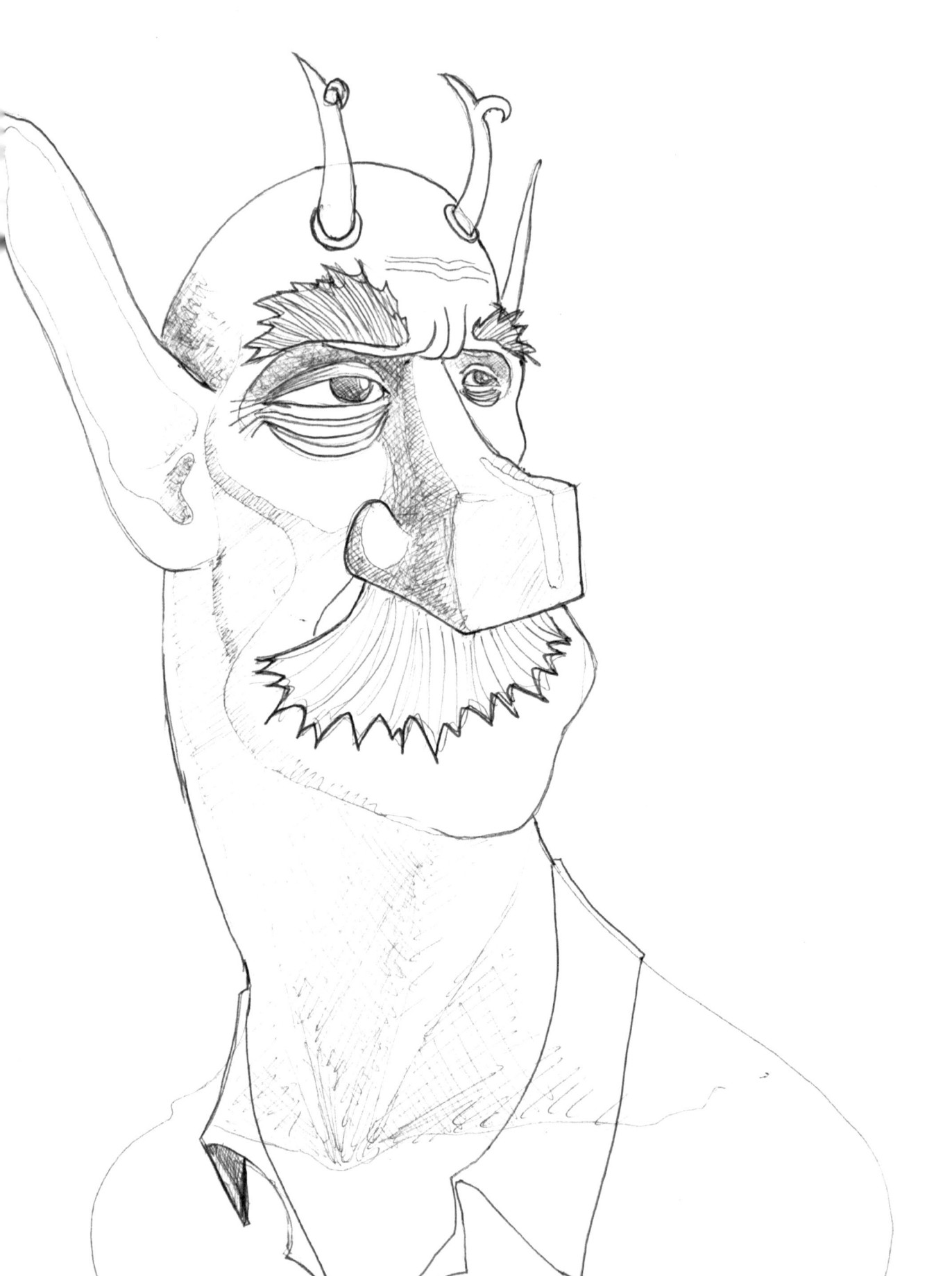

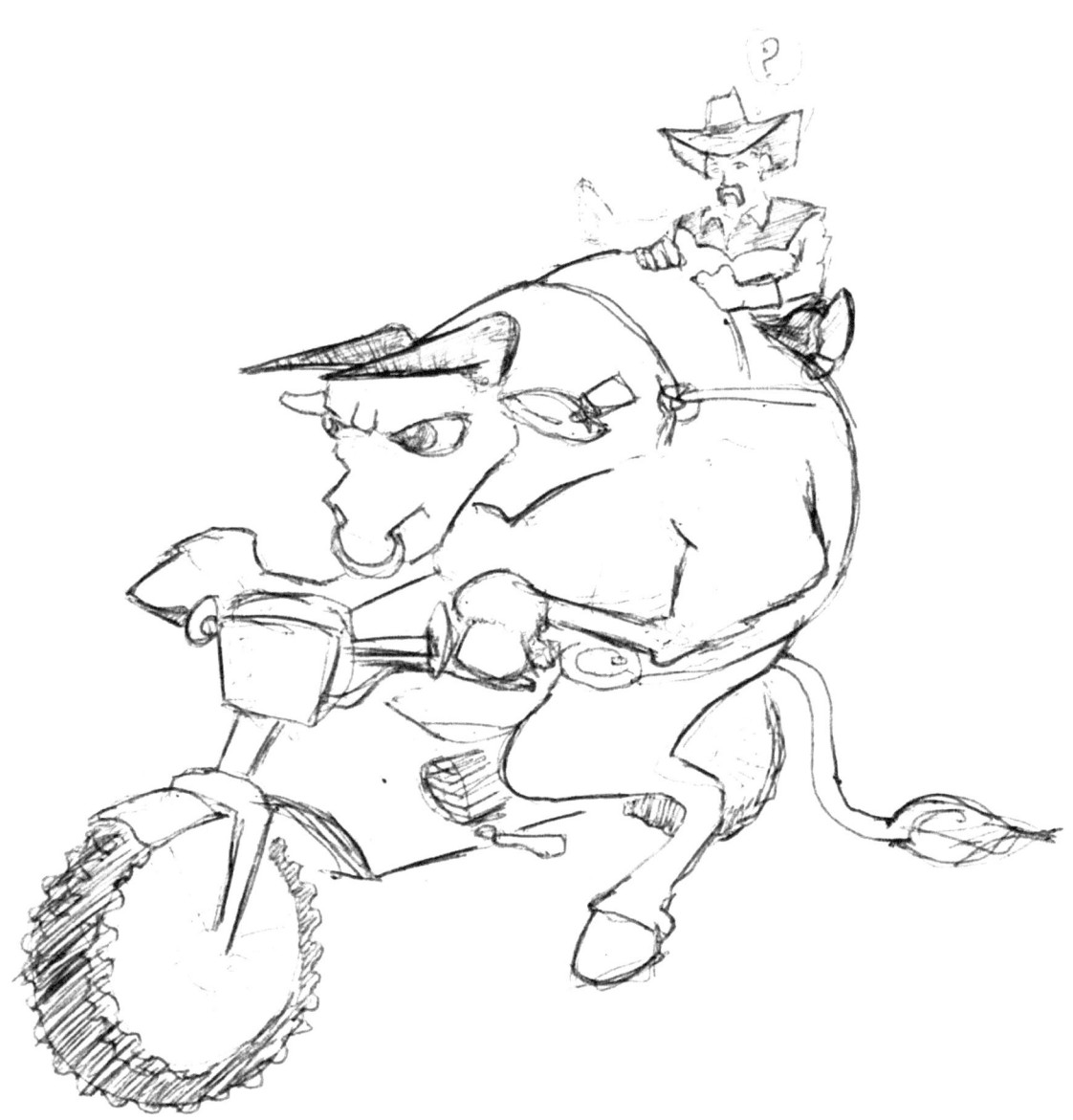

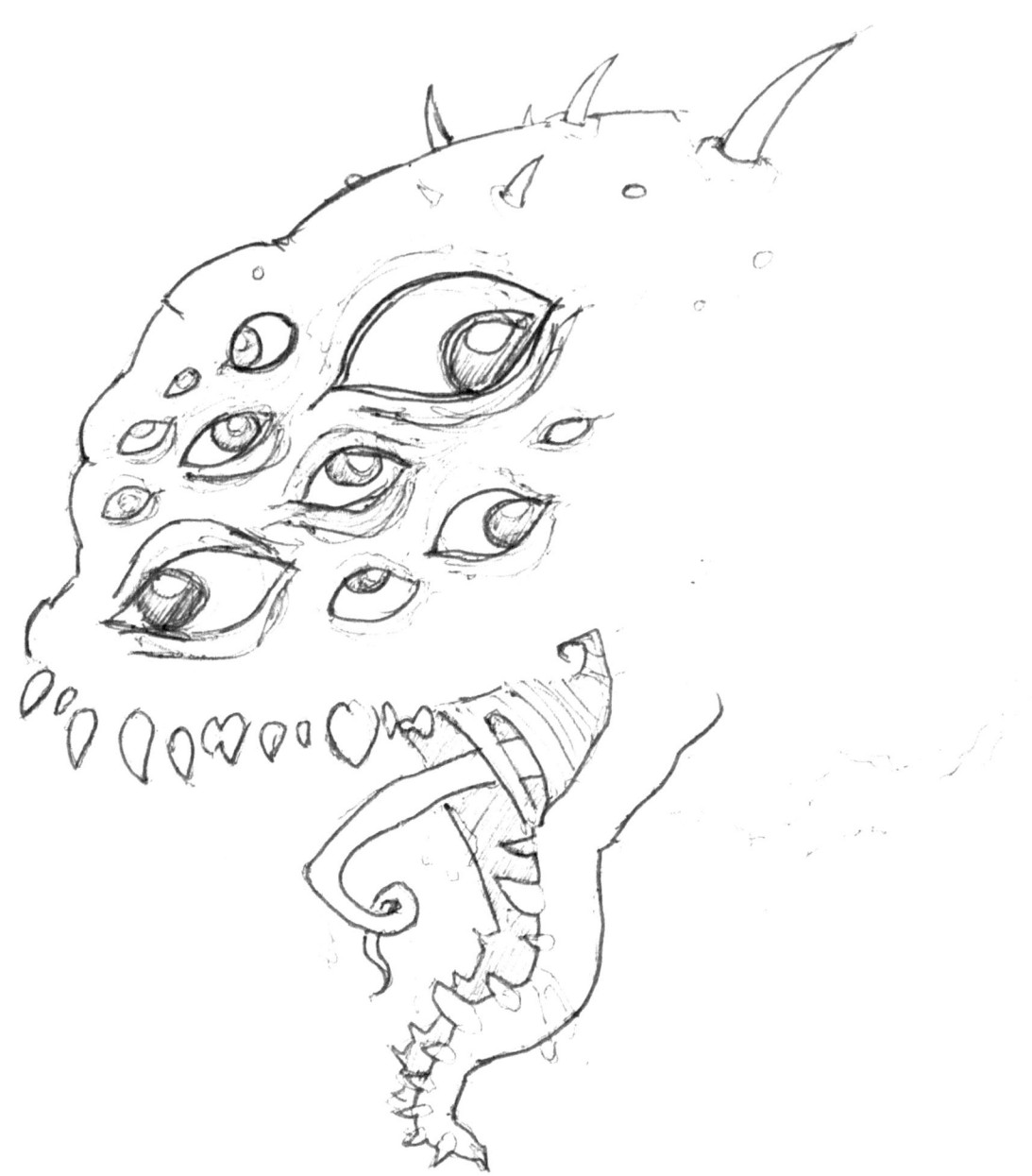

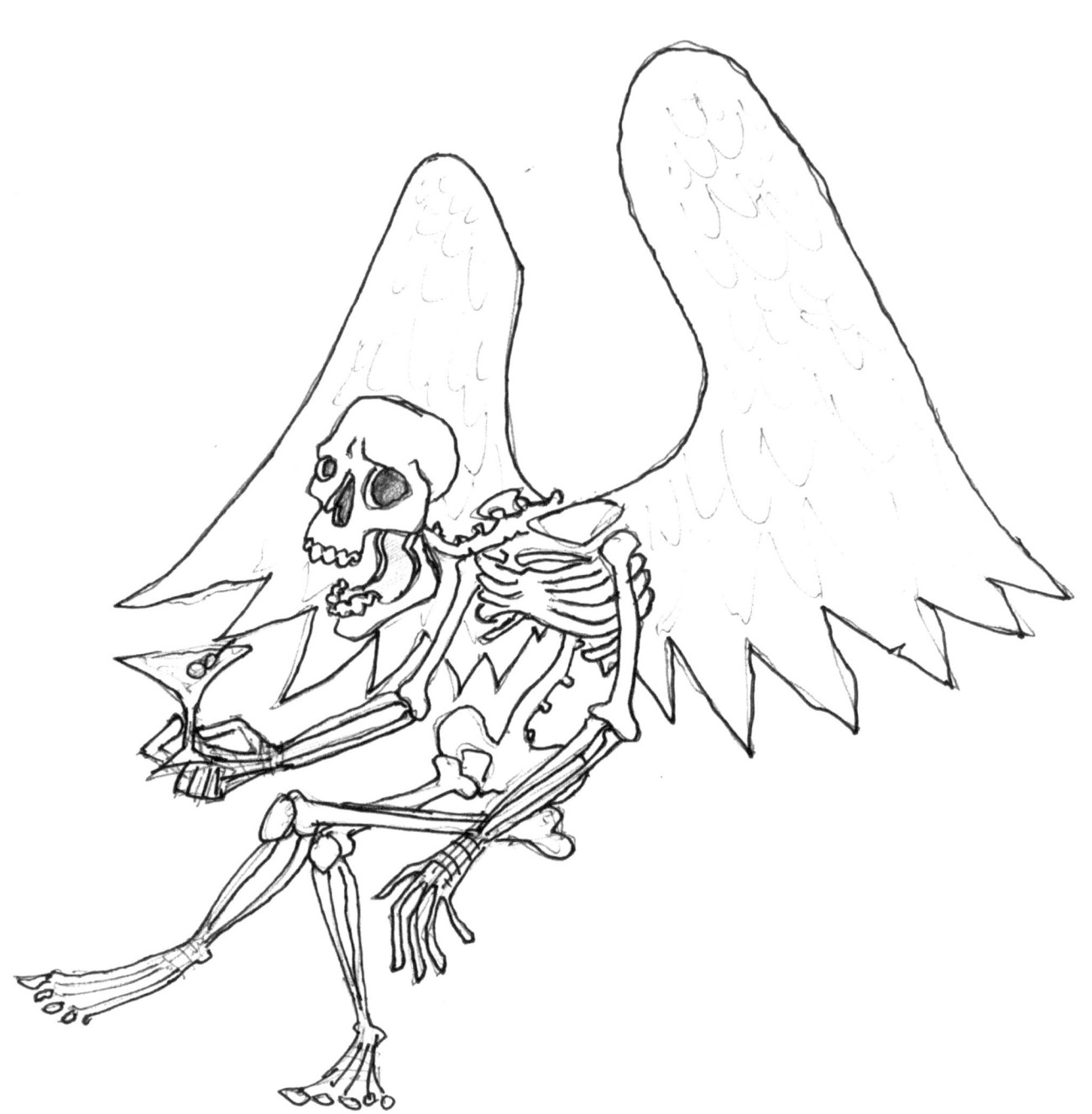

ativism

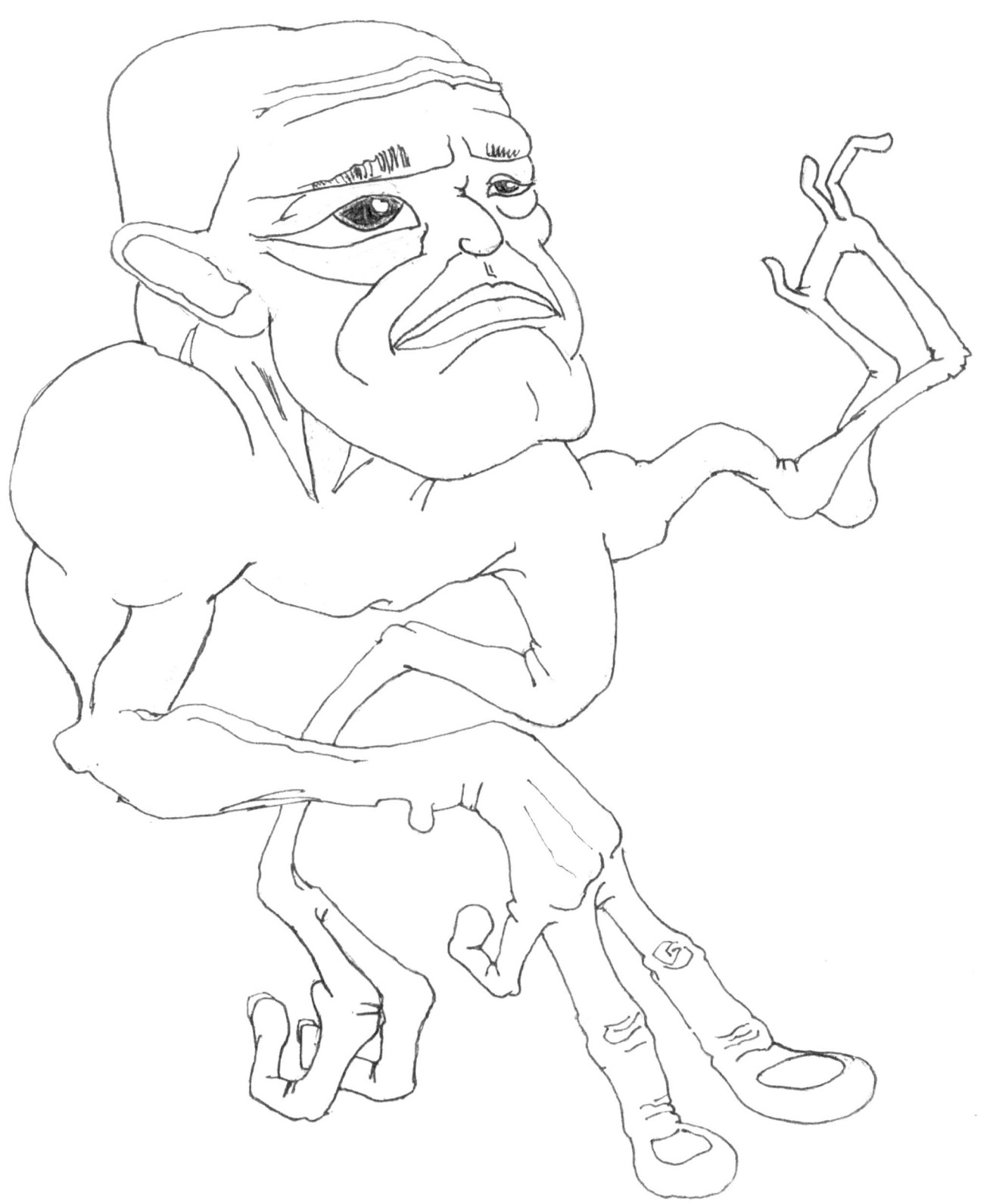

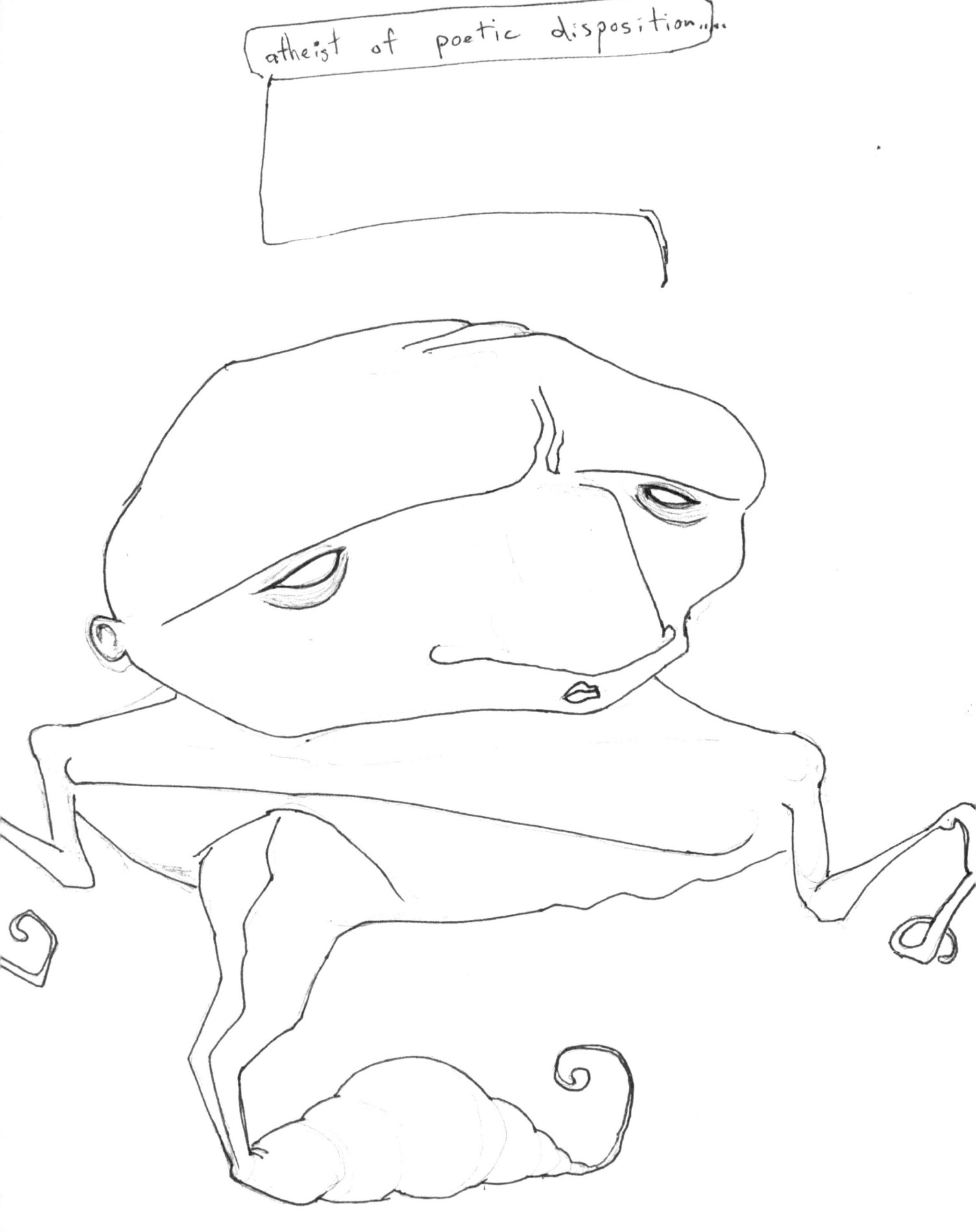

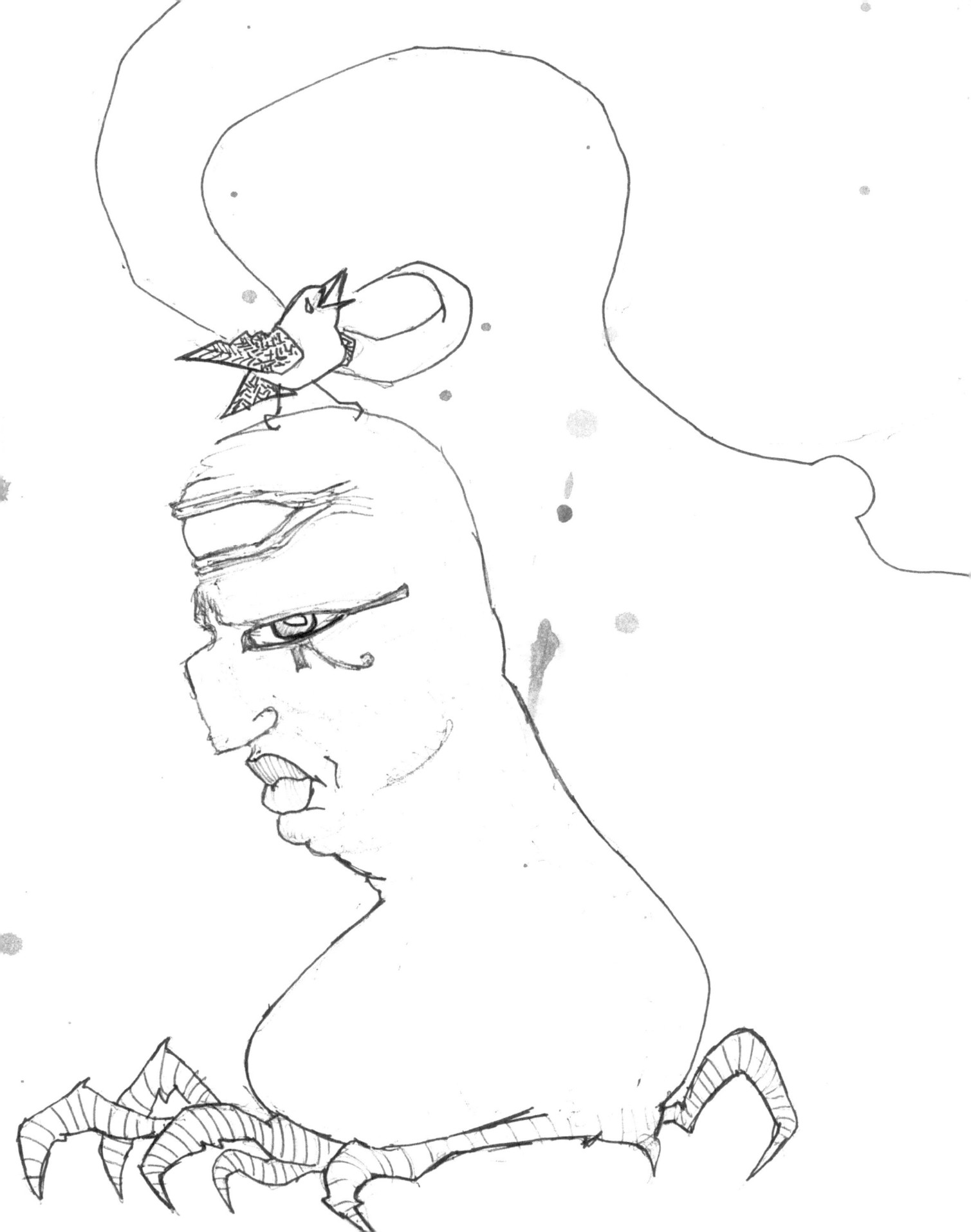

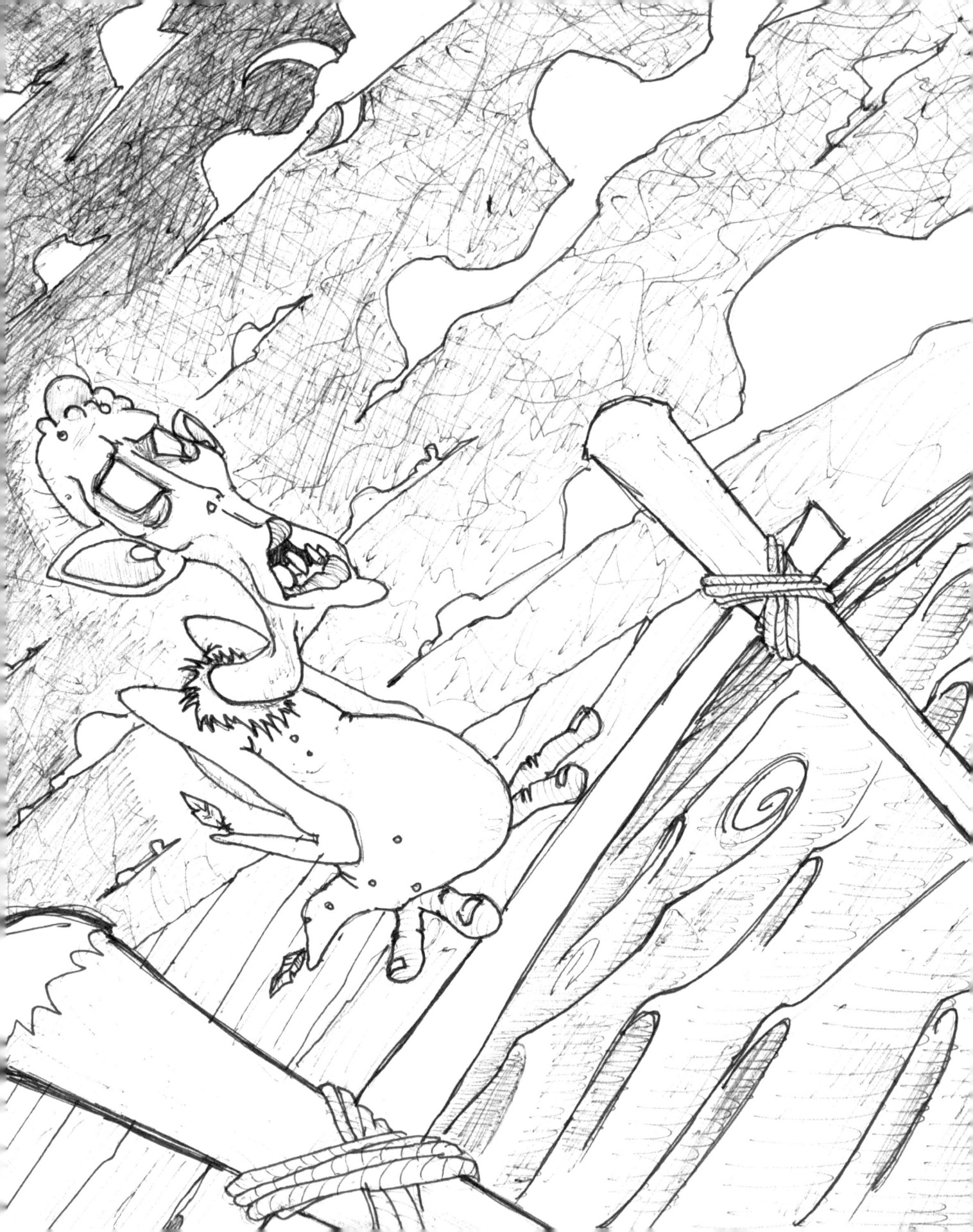

I hope rain sings you to sleep & dawn whispers you back to th

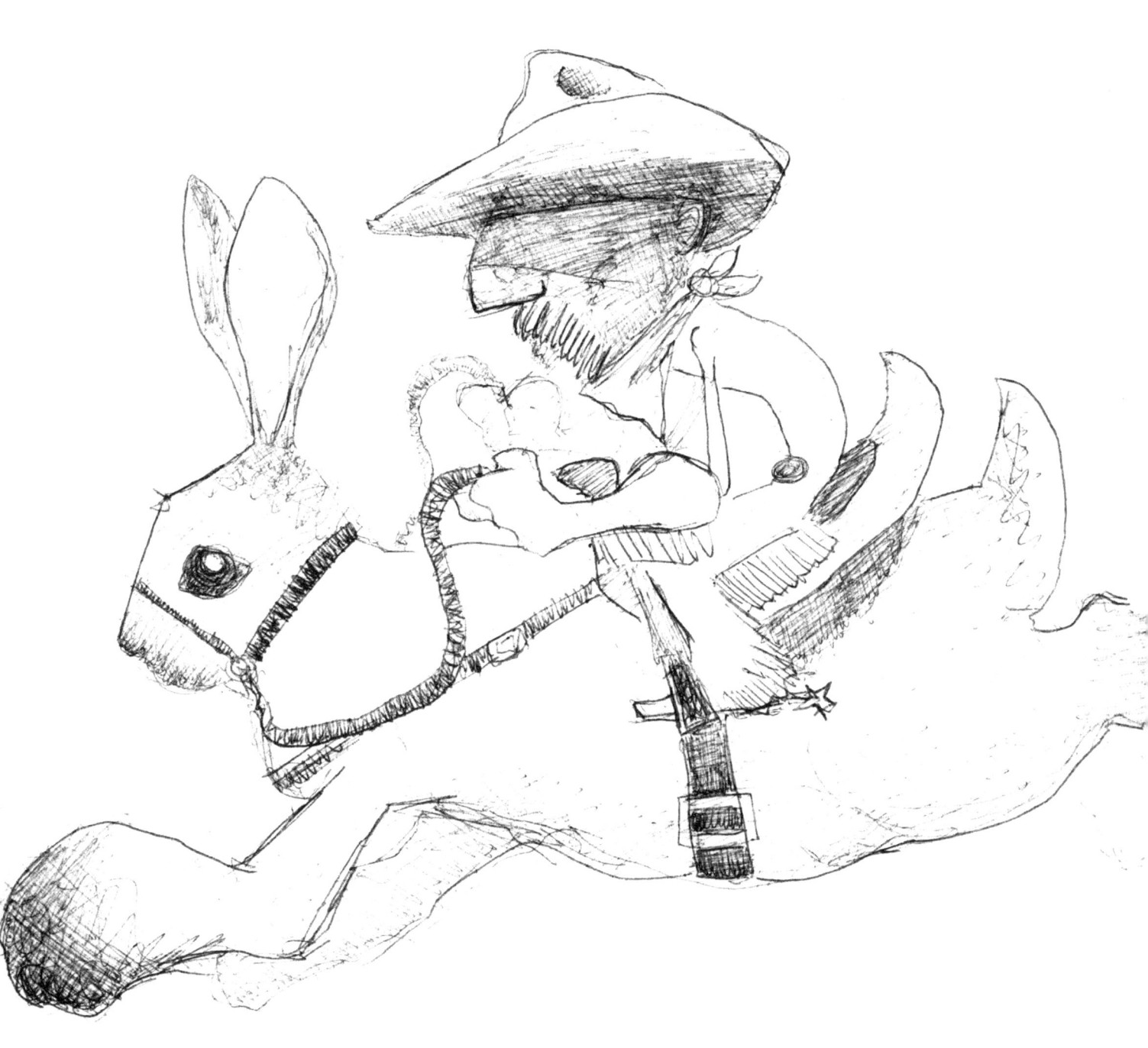

tiny cowboy on giant bunny?

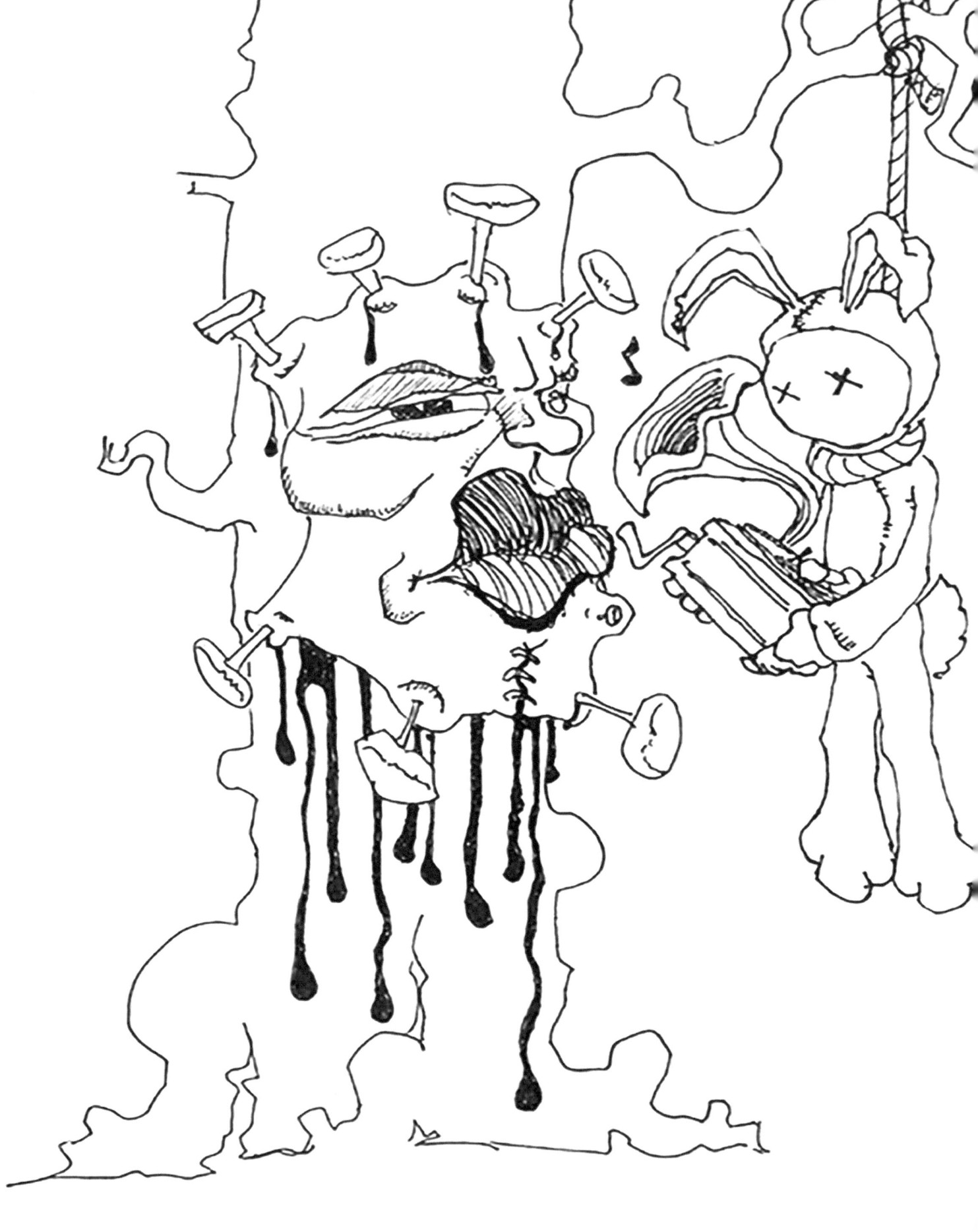

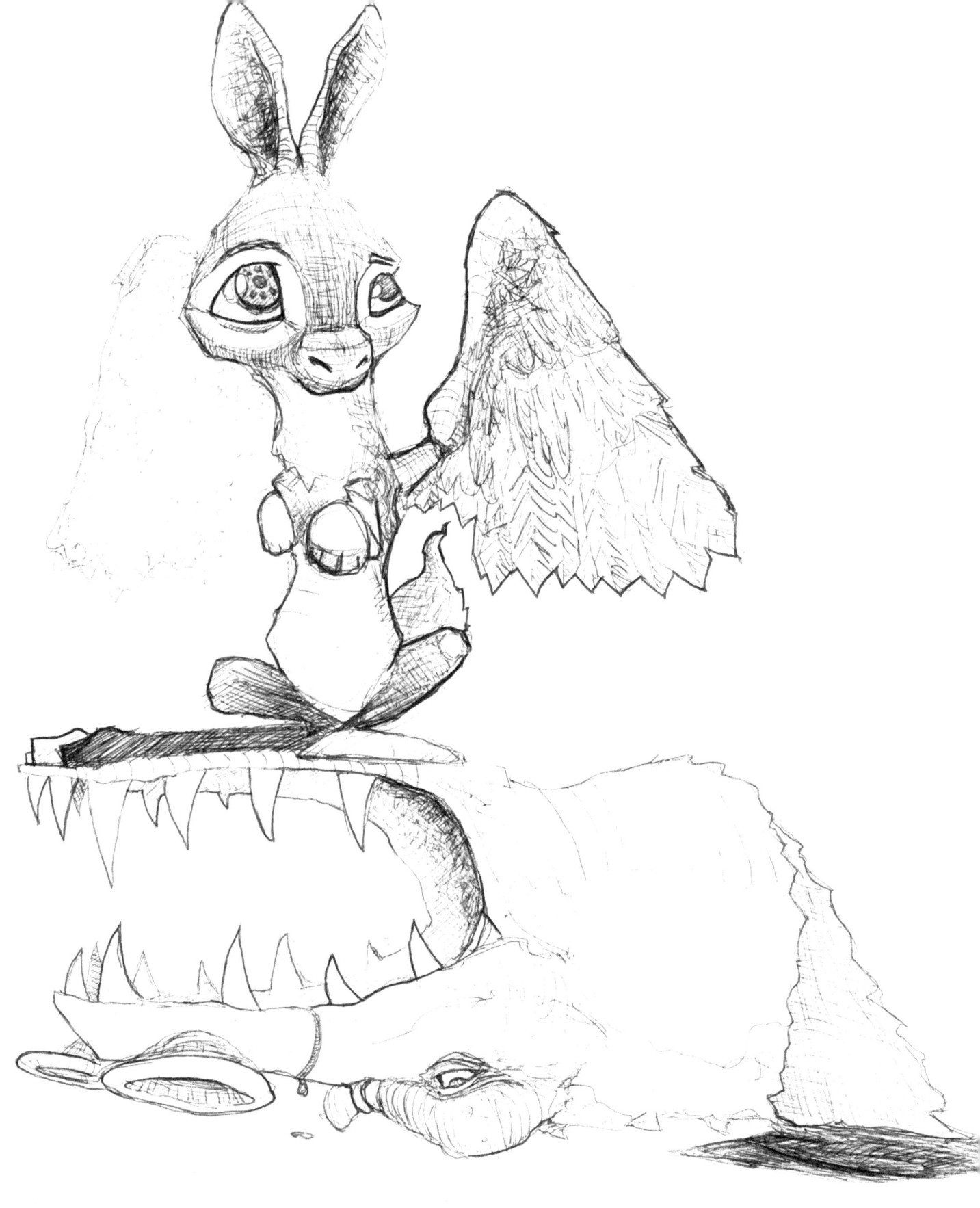

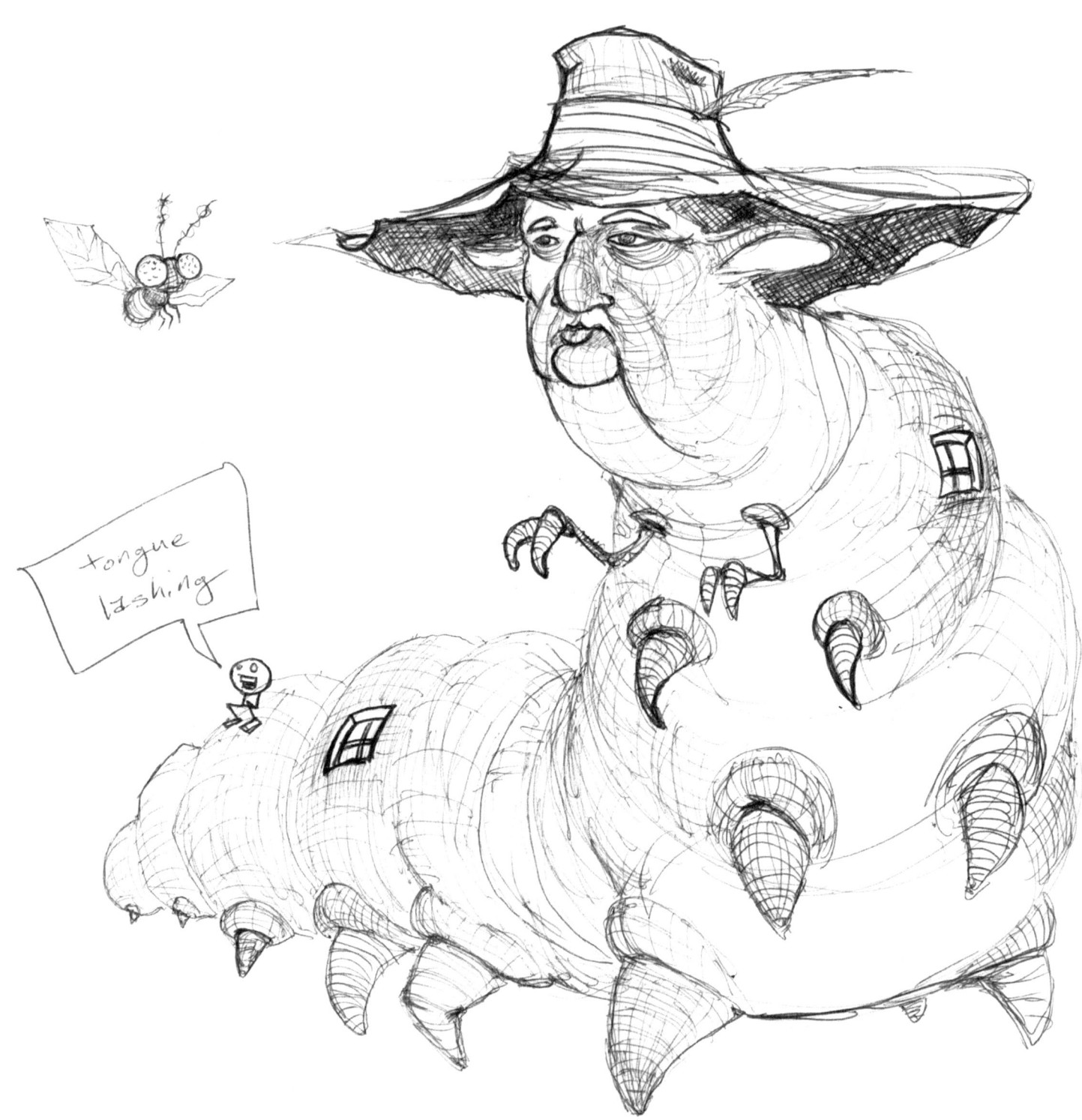

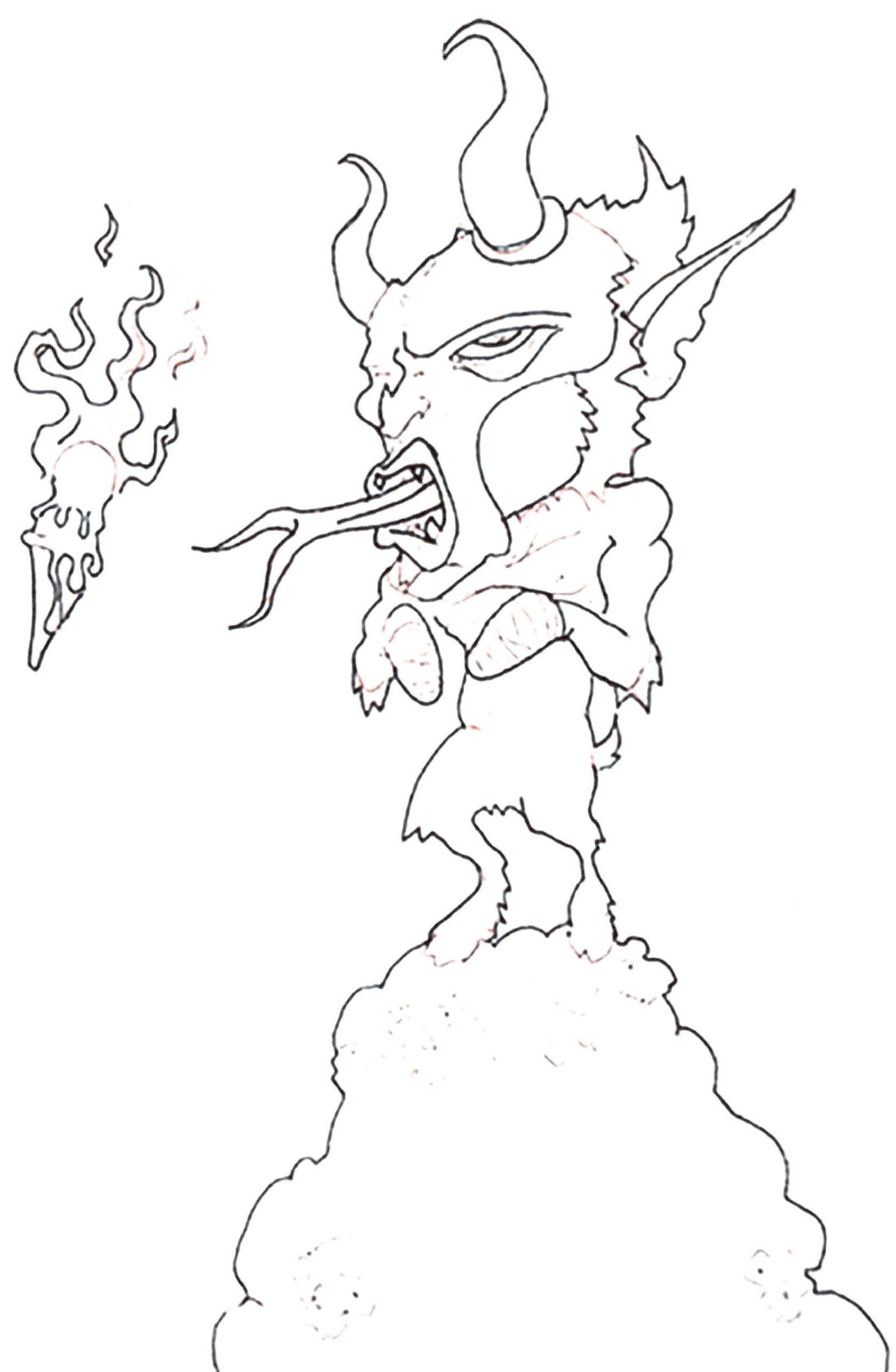

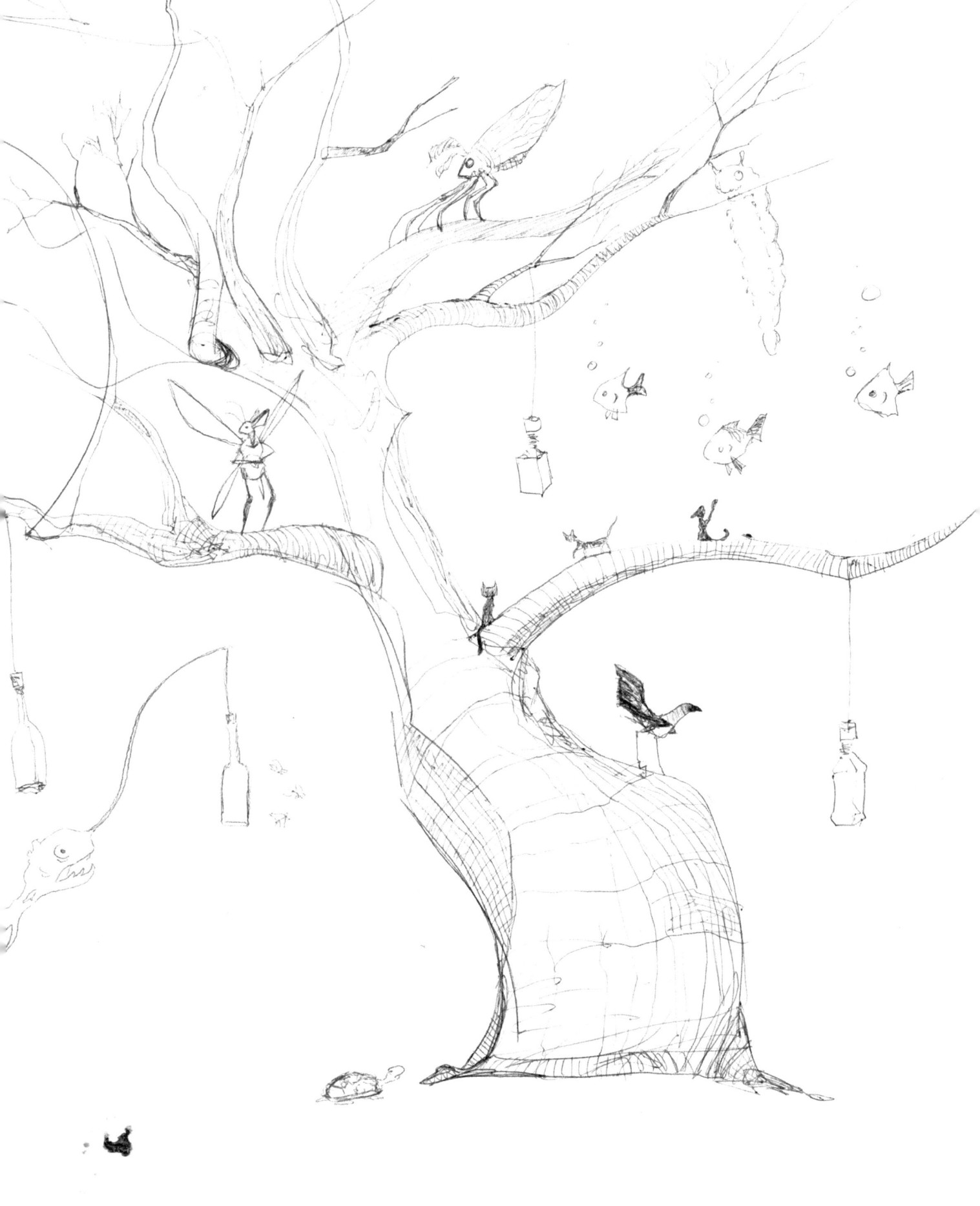

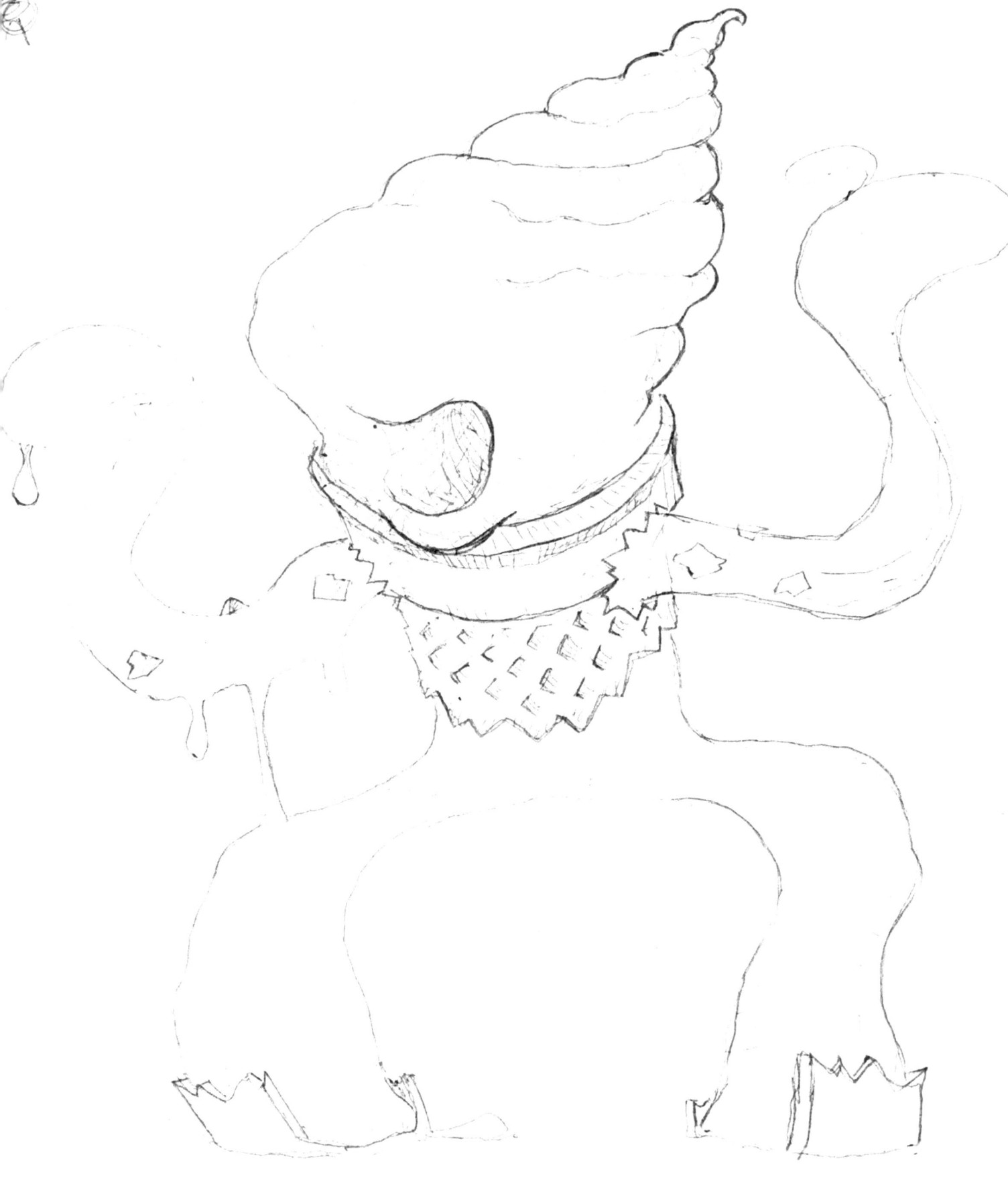

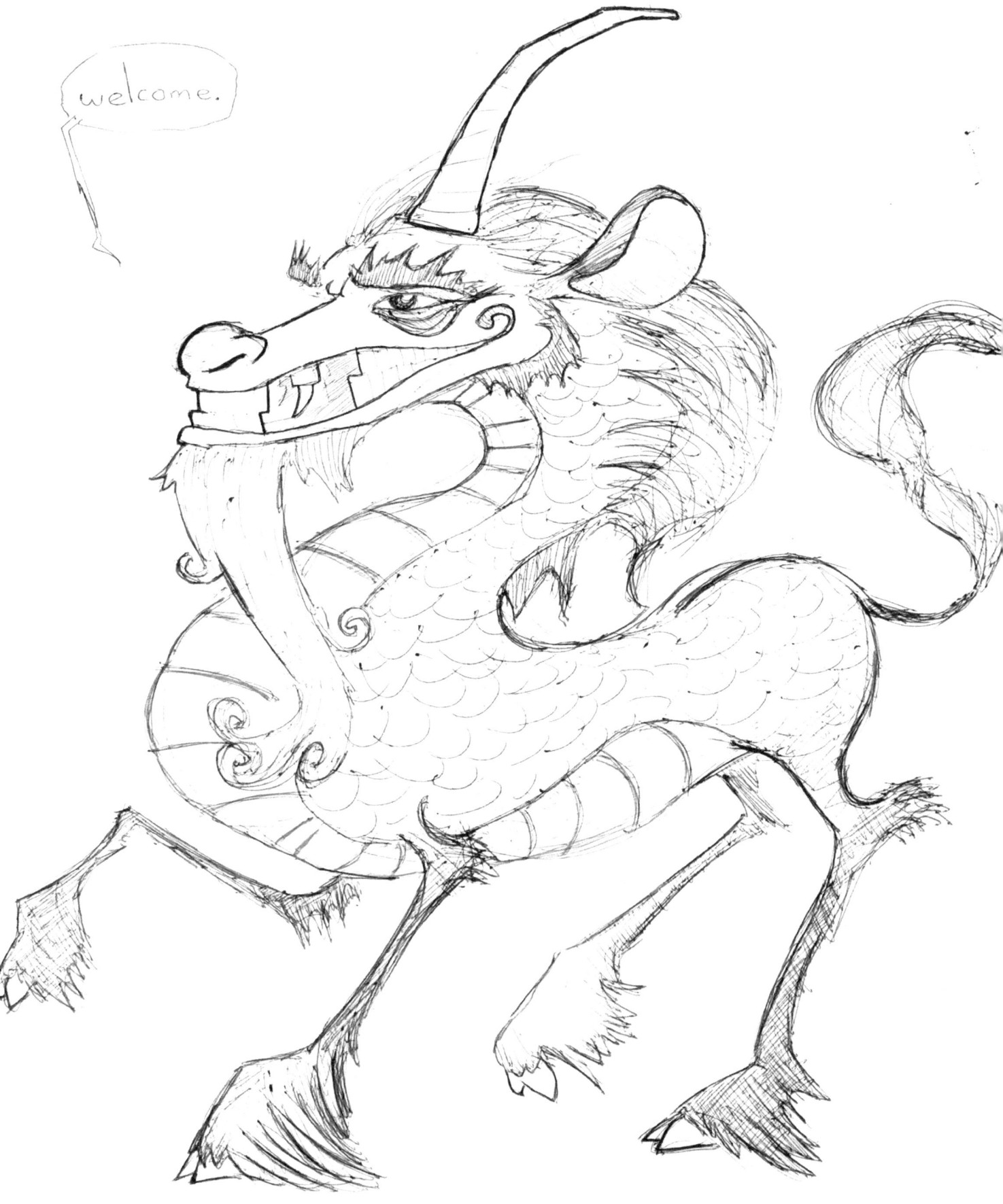

little:
- kidney failure
- suicidal

serotonin syndrome

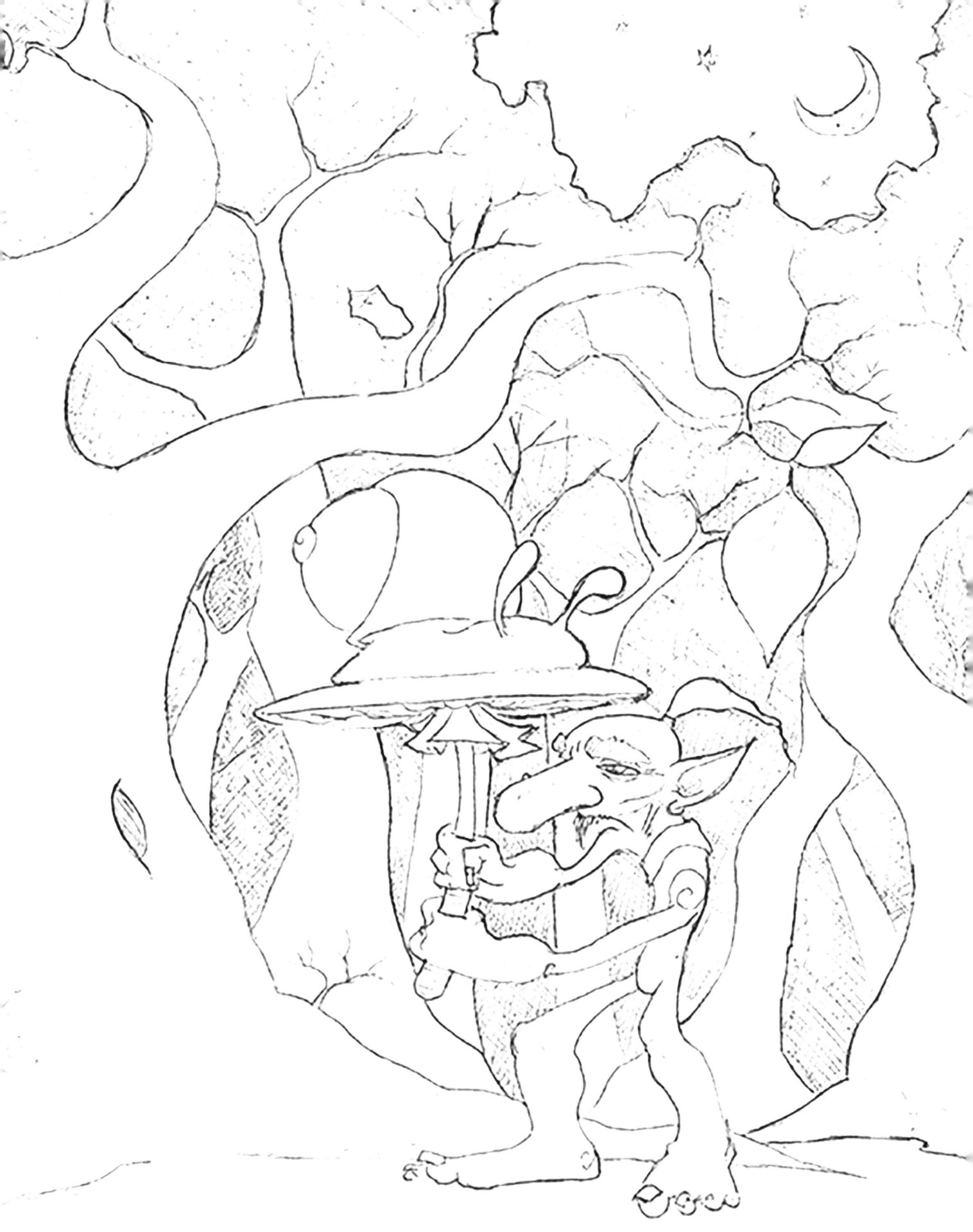

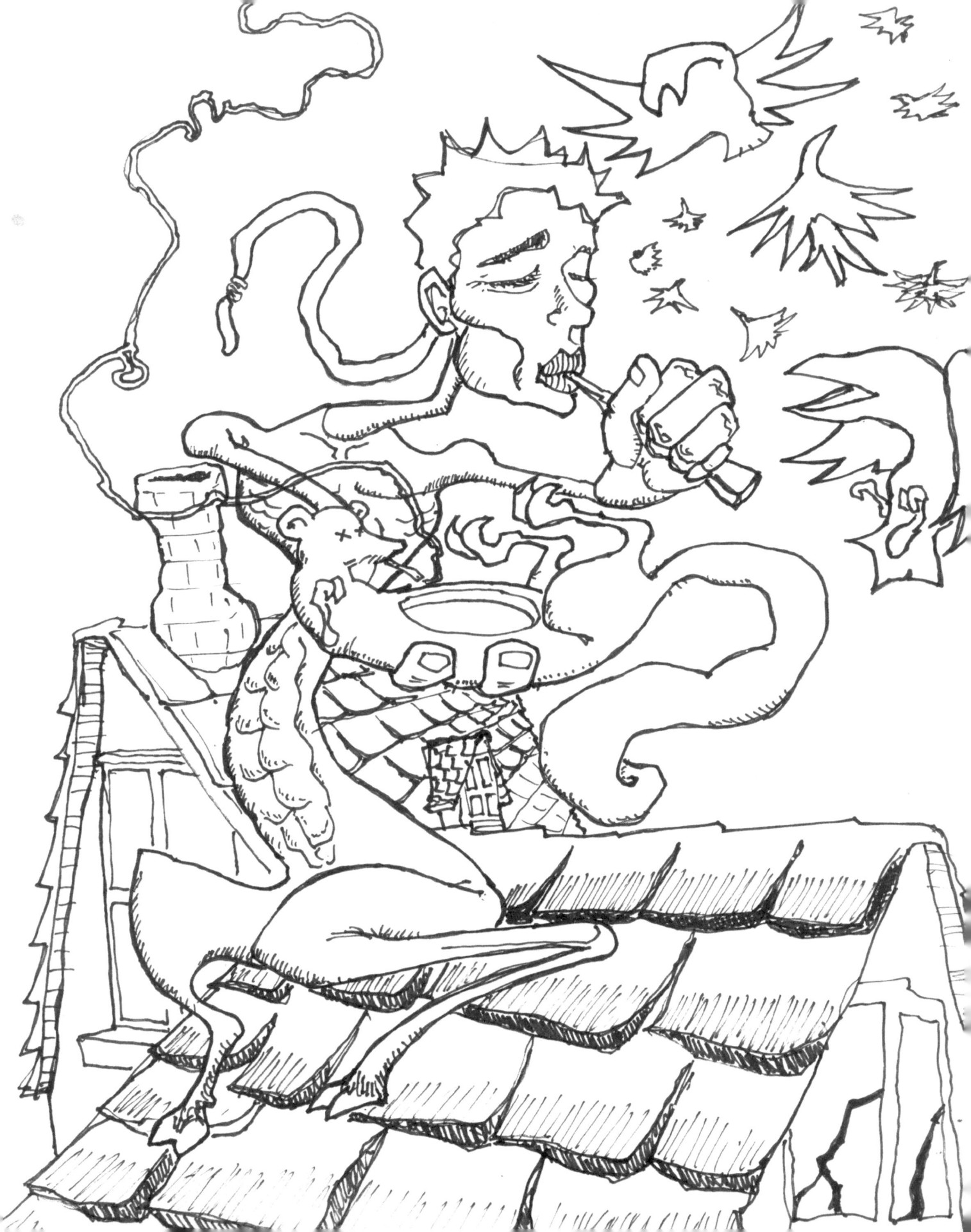

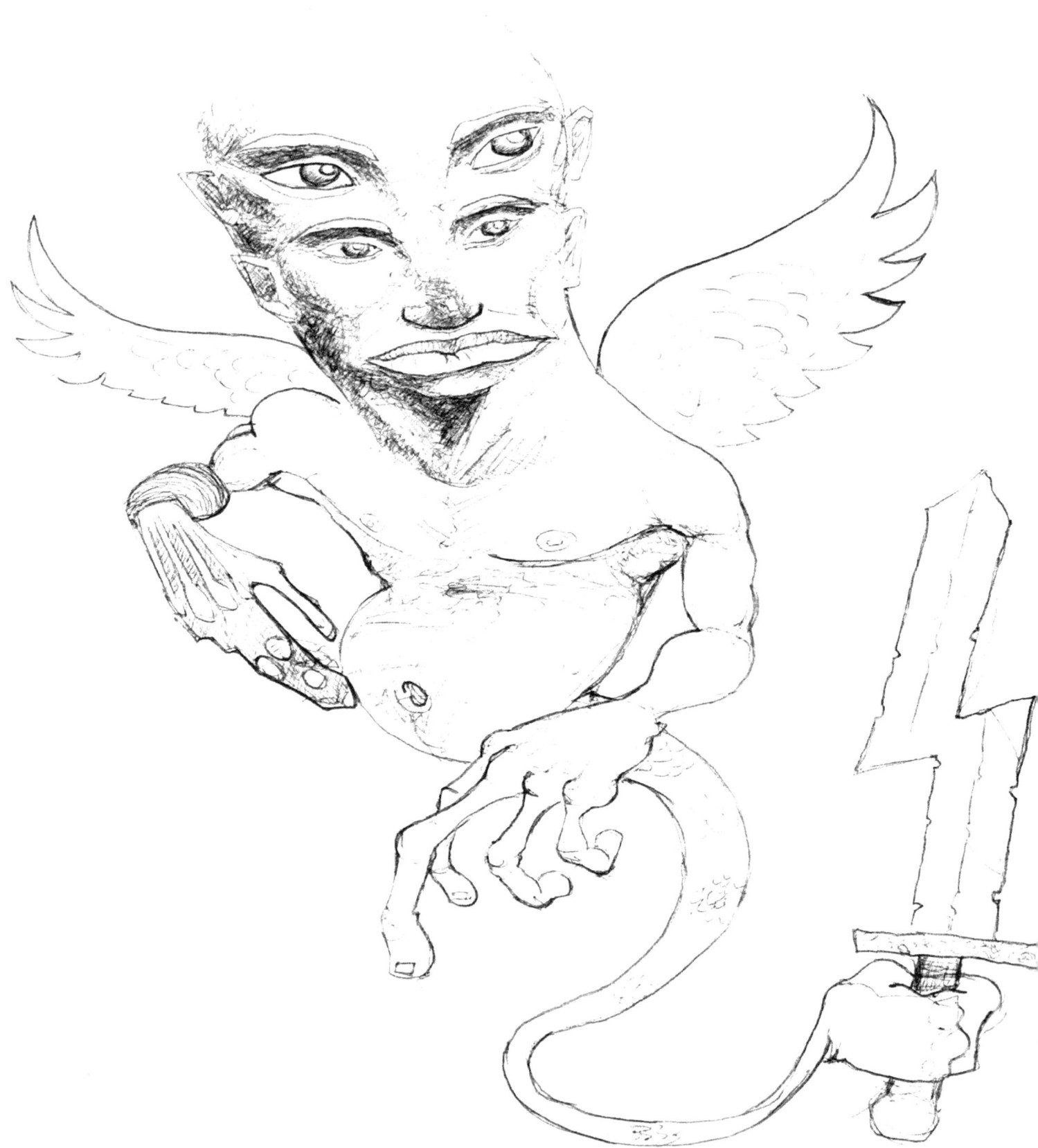

GAMBLING ON RESURRECTION